Leisure Arts 31

Painting the
Detail of Nature in
Watercolour
Sylvia Frattini

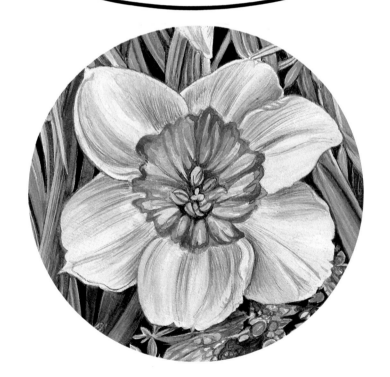

SEARCH PRESS

Wellwood North Farm Road Tunbridge Wells

INTRODUCTION

Ever since I can remember I have sketched and painted, using a variety of media. But only during the last five years have I painted solely in watercolour. At first I worked one hour each day, but I gradually increased this to five hours, during the evenings and at weekends. Because I am fanatical about detail, I spend many hours on each work. During the year, therefore, I produce only a few paintings, and most of them are quite small.

I was brought up in the north-west of England, in the hills of the Cumbrian countryside. My interests have remained there, and landscapes and sheep feature in much of my work. I am interested in all aspects of nature, particularly wild flowers and birds.

With the limited time I have to record information for my work, my camera is an essential aid, and I am seldom without it. Wherever possible, however, I back up the photo references with sketches and colour notes. I also collect interesting and unusual objects, which I sometimes include in my paintings.

For the paintings in this book, I made many plans and sketches so that I knew exactly what to put down and did not need to make more than a few adjustments. When you look at my demonstration paintings, you may find that they could be regarded as complete at the penultimate stage. The final stage depends on the amount of detail one wants. As I say, I am fanatical about detail.

Method and materials

The painting of detail in landscape calls for very precise control of your materials. For me this means using watercolours more opaquely when I want the form to be exact. I tend to thicken my transparent tints with Chinese white, varying this according to the required tone. I also build my washes in deepening layers. This is a safe method of painting, but it is important to keep your mixes pure. I suggest that you use a compartmented palette, as well as separate bowls for broad areas of a single colour.

I use pointed sable brushes, ranging in size from no. 00 to nos. 5 or 6, plus a one-inch square sable for large washes. I do not paint with nylon brushes, although I do use them for mixing colours. Always treat your brushes with respect; they will lose their shape and suppleness if they are left overnight in a jar of water.

Unlike most watercolour painters, I use many colours and work from several different palettes. With my special interest in the countryside, however, it is green that usually predominates. The colours I use for the demonstrations in this book include white, black, sepia, burnt umber, cobalt violet, cobalt blue, Prussian blue, turquoise, lemon yellow, cadmium yellow, yellow ochre, light red, Venetian red, orange, leaf green, Hooker's green (dark), and raw sienna. From these hues I have mixed various tints, such as gray or maroon, which are also mentioned in the text.

For paper, I prefer to use a cream-based Ingres paper, since I find that white papers dazzle me. I stretch the paper before painting on it. For sketching I never use pencils; a very fine pen gives me more control.

Several painting techniques I use seem worth noting here. The principle of painting light to dark should be obvious: since you cannot erase watercolour without unsightly rubbing (unless you lift the wash immediately), it makes sense to lay in your basic tints lightly, then deepen them where necessary once the first wash is dry.

Painting wet into wet allows me to keep edges soft and blend tints subtly (especially in skies, water, and distances). In contrast, the drybrush technique, when I use little or no water with my paint, produces a rough, grainy texture, suitable for bark or stonework. This is a technique, however, that I prefer to use only at the final stage.

I also use stippling, applying tiny dabs of paint with the tip of a pointed brush to build an interesting and colourful effect. This method was a favourite of the Victorian watercolourists, and of Seurat and the French pointillists.

Underlying all these techniques is drawing. Always sketch, when possible, from an actual model, whether a single plant or a general composition. Analyze the structure or form, be it the skeletal structure of flowers and leaves or broad masses of terrain or rock formations. Do not niggle, but try to develop a bold, rhythmic use of line, working from the wrist and capturing nature's grace, which reveals itself in all organic growth. And never throw away an honest sketch; the time will come when you will find a good use for it!

Flowering water lilies

Size: 8¾ × 8¾ inches (222 × 222mm)
Paper: Ingres Fabriano 90lb. (160gsm)
Brushes: sable nos. 00, 0, 1, 5

I discovered this subject – a lily pond – by chance when I was visiting friends one summer. What attracted me to it were the sweeping patterns and the movement created by the large, multicoloured leaves. The beautiful lilies, some almost hidden, just appearing from underneath the leaves, gave added interest.

On this visit I did not do any preliminary sketches but photographed the pond from several angles. Some time later, when I decided to use this theme for a painting about summer (pages 5–7) I returned to the pond to make sketches – only to find that it had been cleared. I have had to rely, therefore, entirely on my photographs. At first I wanted to include some of the frogs living in the pond, but decided to leave them out.

Preliminary work

Before any paint is applied, careful planning is needed to establish the correct proportions of the leaves and flowers and to develop the complicated composition. I find that the areas of water and the shadows make a pleasing contrast to the plants.

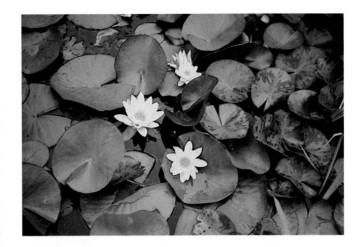

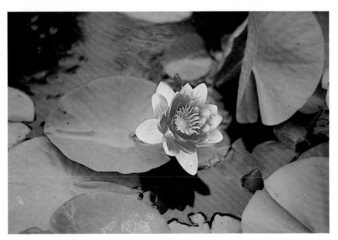

Photographs of water lilies (previous page) with (right and below) contour drawings of water lilies and leaves which begin to describe the tone of variations of water and shadow.

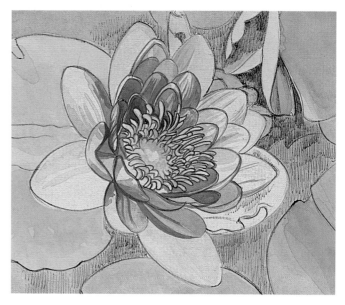

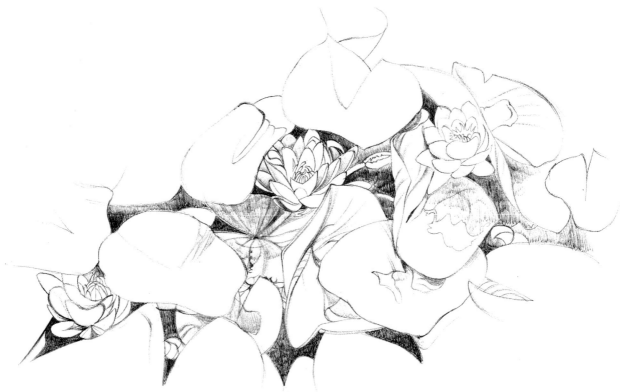

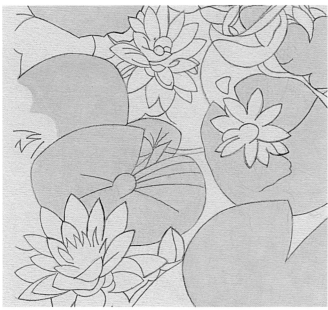

Stage 1 (detail)

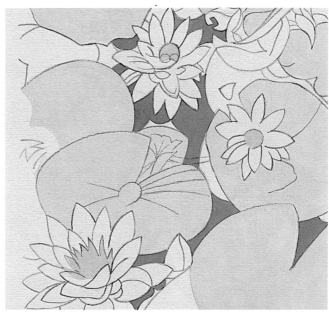

Stage 2 (detail)

Stage 1

After outlining the flowers and leaves in pencil, I begin working into the leaves with a basic colour wash, mixed from Hooker's green and white, and applied with a no. 5 brush.

Stage 2

Keeping the paint thin and using a no. 1 brush, I fill in the flower petals with a very pale mixture of white and yellow. With the same brush, I dab a light yellow mixture into the centre of the flowers. I then block in the water areas using a mixture of Prussian blue, black, and white, with a no. 0 brush.

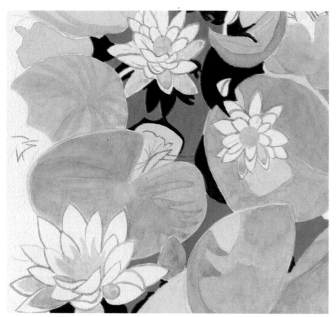

Stage 3 (detail)

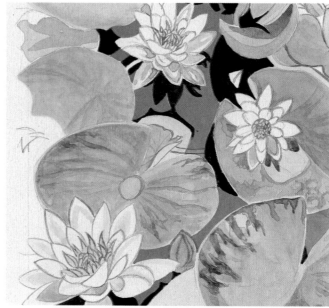

Stage 4 (detail)

Stage 3

With my no. 0 brush, I fill in the shadow areas in the water with a deeper tone than the water itself. Then I begin to work into the petals and leaves. Working from light to dark, I make the deepest shadows on the petals that are covered by water.

Stage 4

I continue to work on the leaves and petals with a fine brush and gradually strengthen all the colours. For the detail on some of the leaves, I use a mixture of violet and cobalt blue.

Stage 5 – the finished painting (page 7)

With the point of a no. 00 brush, I now work meticulously into the leaves. I use very fine lines to make the flowers look more realistic. Then comes the most difficult part in this picture: painting the water that has gathered inside some of the leaves. By using Chinese white semi-transparently, I am able to suggest the droplets on the surface of the leaves.

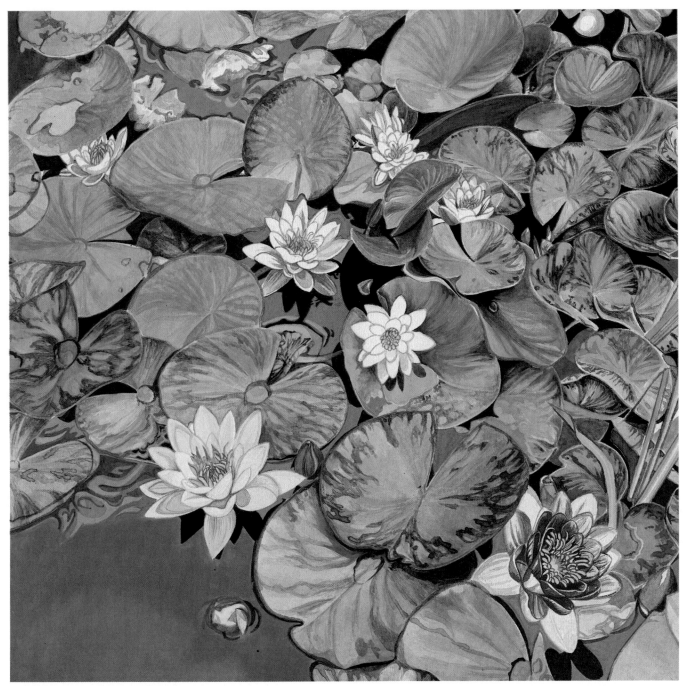

Stage 5 – the finished painting

Curious

Size: 8¾ × 8¾ inches (222 × 222mm)
Paper: Ingres Fabriano 90lb. (160gsm)
Brushes: sable nos. 0, 1, 3, 5

Stone walls are a fascinating subject to paint. I have always been intrigued by the weathered, irregular outlines of the stones, for they contain a surprisingly wide range of textures and colours. They provide the cows in the photograph and the sheep in the picture (as well as myself) with an endless source of curiosity.

This painting (pages 10–11) began when I found an attractive, well-weathered wall supporting a flourishing growth of lichen and moss, on a wet afternoon in late spring. At the time I made only rough notes and sketches from the car, but I took many photographs to capture the rich colours, which were enhanced by the rain.

Overview of the work

In composing the painting, there are four areas to consider: the wall, middle ground, the background, and the sky. The wall offers the greatest challenge – that of capturing those rich colours and textures. The sharp shadows and varying outlines also provide plenty of opportunity to experiment with different techniques.

In the middle ground I decide to include the sheep, which seem to me an integral part of the Cumbrian landscape. Their entangled coats also add to the painting's interest.

For the background, I want a pleasant, peaceful scene, which I find in the nearby fields. Lastly I keep the sky quiet and simple as a contrast to the other, detailed work.

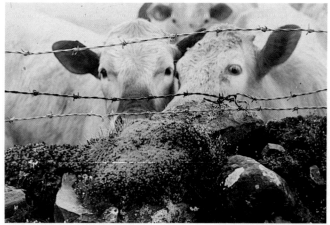

The inquisitive cows I photographed become 'curious' sheep in the painting

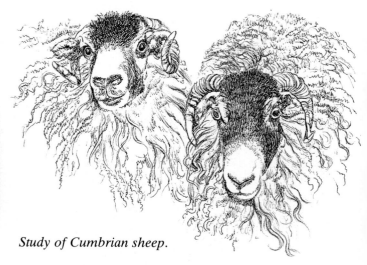

Study of Cumbrian sheep.

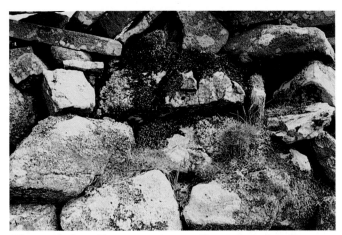 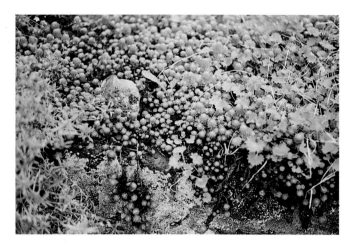

Photographs of 'an attractive, well-weathered wall, supporting a flourishing growth of lichen and moss'.

Stage 1 (page 10)

Initially I make a fine pencil drawing outlining the stones. I then paint over these lines with a neutral colour – a light mixture of cobalt blue and gray – using a no. 5 sable brush.

Stage 2

Keeping the paint thin, I try to capture the shape and colour of the stones, working from light to dark. Again I use mixtures of cobalt blue and gray, but this time with a no. 3 brush. By painting wet into wet, I am able to create softer edges and model the stones more easily. I allow the paint to produce its own patterns as it dries. I then add some highlights with opaque white.

Stage 3

Now I introduce the various plant structures and stone textures. After sketching these lightly in pencil, I progress from light to darker tones, still keeping the paint thin. For the moss and lichen, I use yellow ochre, Hooker's green, and lemon yellow, as well as a maroon mixture. For the stone textures, I continue to use a mixture of cobalt blue and gray. I also fill in the shadows between the stones with dark gray. Throughout this stage I use a no. 1 brush.

Stage 4

Here I introduce deeper tones into the stones and shadow areas. To emphasize the stone textures, I employ the drybrush technique and, to suggest more depth between the stones, use a very dark brown. I strengthen the colour throughout with thicker paint, using a fine brush. Then, with the tip of the brush, I work very carefully into the plant structures and stones.

Stage 5 – the finished painting (page 11)

Using a worn no. 1 brush, I continue working into the painting. The decision of when to stop and call the painting complete has to do with how much detail I want. At first glance all the detail may appear complicated and difficult to achieve. What is needed, however, is primarily care and patience. As long as I take one step at a time and pay particular attention to the delicate structures on the wall, the total effect can be successfully produced.

You will notice that, in drawing the sheep, I have used a fine-tipped brush to suggest the texture of the fleece; also that the distant greens are softer in hue and tone than the foreground plants.

Stage 1

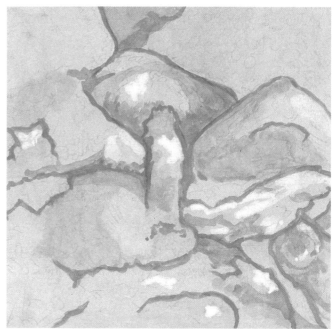

Stage 2

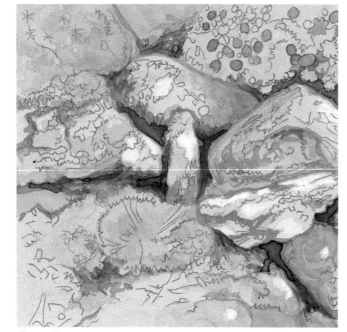

Stage 3

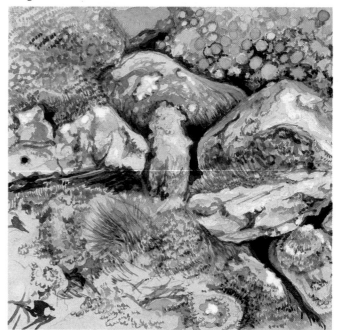

Stage 4

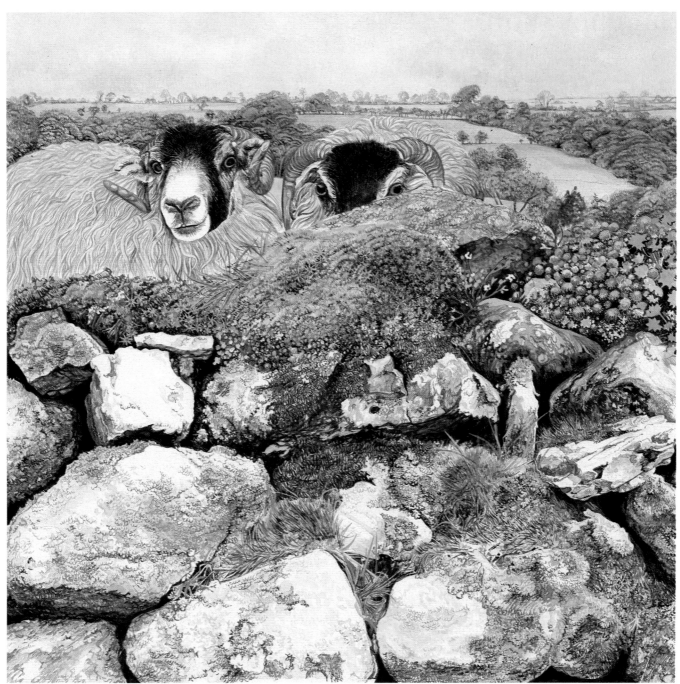

Stage 5 – the finished painting

Summer shore

Size: 6¼ × 9 inches (160 × 230mm)
Paper: Ingres Fabriano 90lb. (160gsm)
Brushes: sable nos. 0, 1, 2

As a child, a visit to the seashore at Allonby was always a special occasion for me; and as I grew older, many of my leisure hours were spent strolling and sketching along a favourite stretch of Solway coastline. Whatever the season or the time of day, the seashore has never failed to interest me, with its driftwood, beautifully coloured stones, variety of shells, bird skeletons, seaweed, and wild flowers.

When, in June 1985, I returned to take a fresh and closer look at my childhood seashore, I was intrigued by the wealth of detail to be found in a relatively small space. How many people, I wondered, walk these parts every day without really observing the sights underfoot? I was amazed to see goose grass struggling to survive among the pebbles – a plant that grows in profusion in my own garden. It was, however, the pebbles, with their endless variety of shapes, colours, and textures, that made me want to paint this scene. I was also intrigued by the shells – especially when parts of them had been worn away by the sea and sand to reveal their internal structure.

With this painting (pages 15–17) I had the opportunity to paint almost the entire composition from life, for, after my preliminary sketching and photographing, I collected the more interesting objects and brought them to my studio.

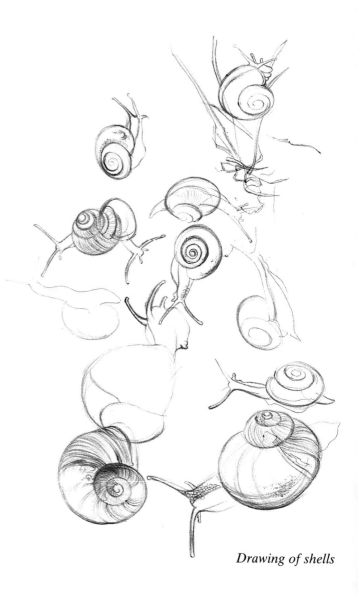

Drawing of shells

Sketch from a photograph

Structure of shells

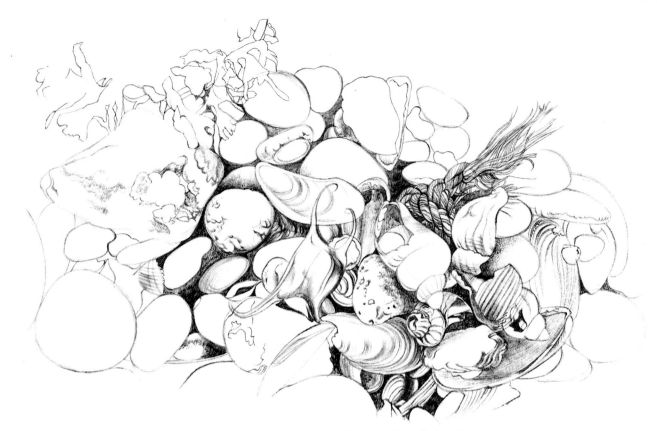

Compositional sketch

Study of seaweed

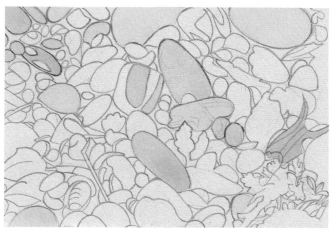

Stage 1 (detail)

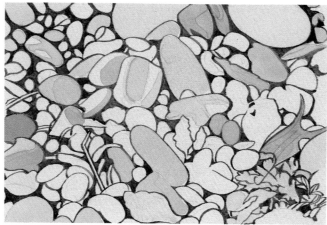

Stage 2 (detail)

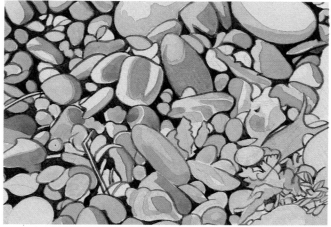

Stage 3 (detail)

Stage 1

I make a pencil drawing outlining all the shapes: pebbles, shells, and other objects. With light washes and a no. 2 brush I then fill in some of the larger pebbles.

Stage 2

Using the same brush but stronger washes, I block in more of the shapes. Then, using a no. 1 brush, I fill in the area between the shapes with a dark gray mixture.

Stage 3

Here I block in the remaining shapes with even stronger colours and deepen the colour of some of the areas between the shapes to create greater depth. With the deeper tone used on the shape itself, I fill in some of the main shadow areas.

Stage 4 – the finished painting

With my finest brush, I continue to work into all the shapes until I am satisfied with the effect. I give particular attention at this stage to the seaweed and the shells. For the pebble textures I use a stippling technique.

Finally, to give my picture strength and unity, I include some sea bindweed in the foreground. Its trailing stems, mass of heart-shaped leaves, and conspicuous trumpet-like flowers complement the rest of the scene. I am lucky to be able to use a similar plant growing in a hedge near my home as a reference.

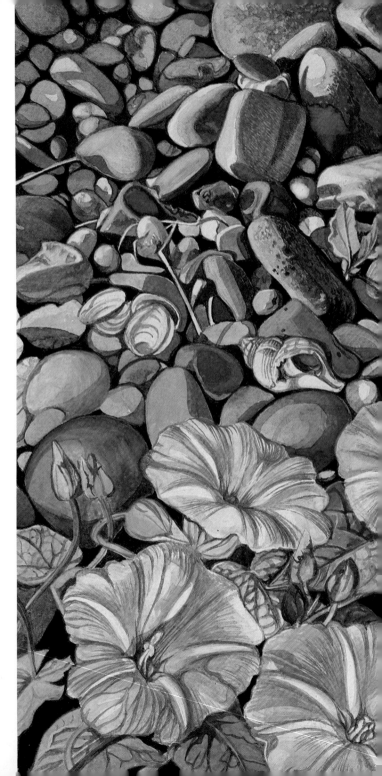

Stage 4 – the finished painting

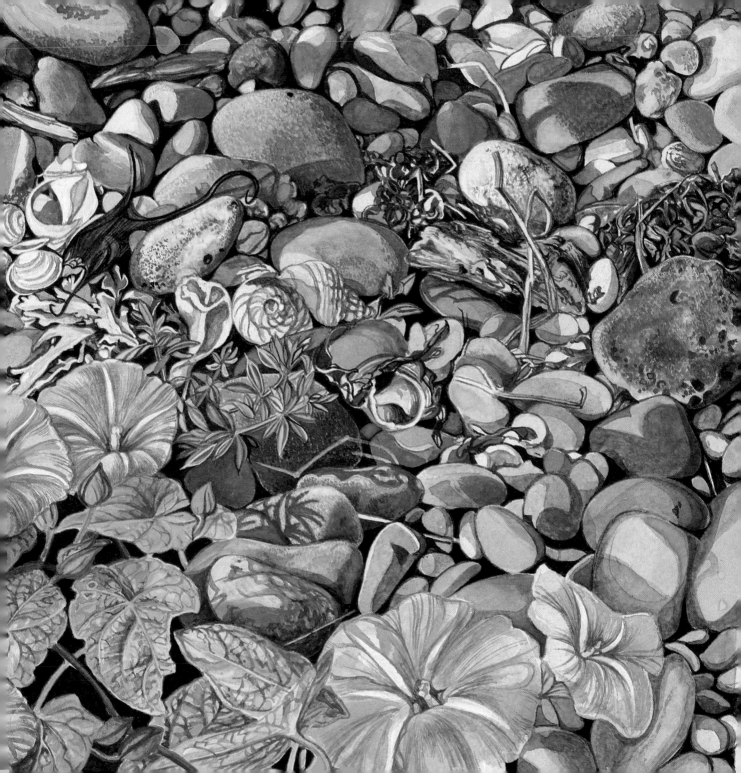

Autumn poppies

Size: 6¼ × 9 inches (160 × 230mm)
Paper: Ingres Fabriano 90lb. (160gsm)
Brushes: sable nos. 0, 1, 2

I always enjoy painting flowers, particularly those which grow in the wild. With the masses of poppies that flourished in the hedgerows and fields in 1985, I had plenty of opportunity to work from life and to capture accurately the true, brilliant colour of the poppy.

This painting (pages 20–1) is based on photographs taken in September from the edge of a wheatfield quite close to my home. Poppies are difficult to photograph well because they are so delicate that they are never still. Where I live I am lucky enough, however, to be able to paint from the flowers themselves right up to the end of October. What appeals to me most is the striking contrast of the petals of the poppies against the rich, dark centres.

In composing the painting, the placement of the flowers is vitally important, and I have tried several positions of the heads before finding the most effective grouping. Finally, to balance the picture, I have included small daisies and long strands of wheat, which offset the poppies.

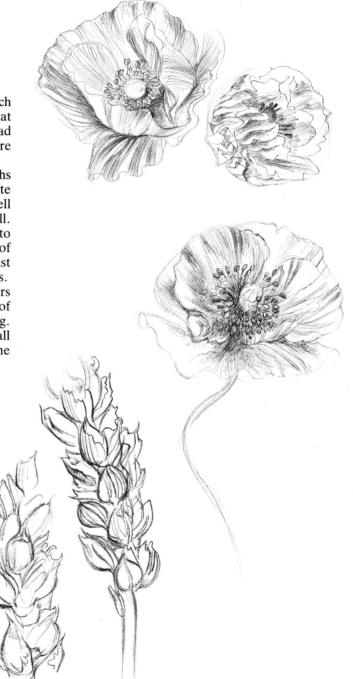

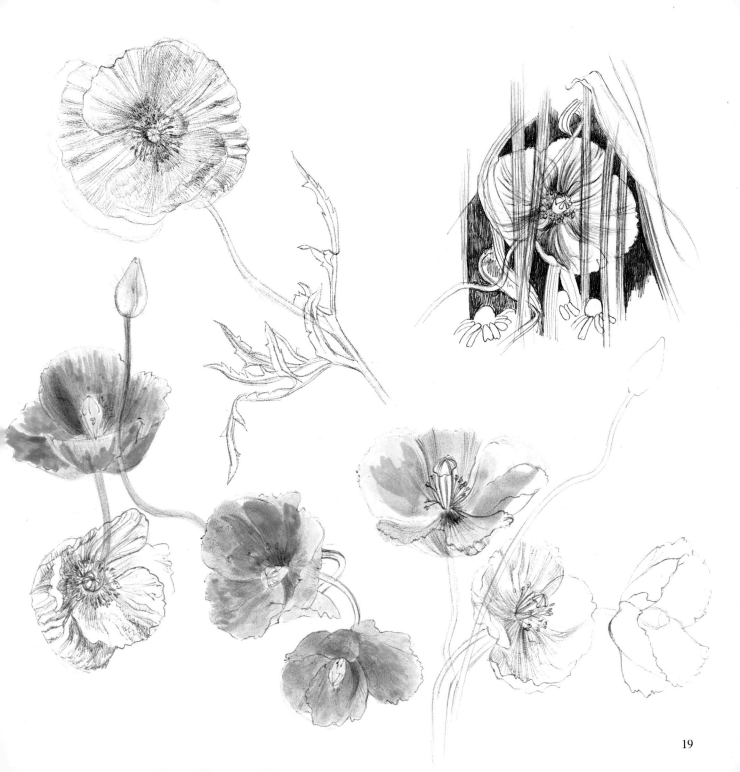

Stage 1

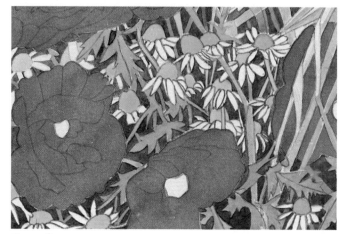

Stage 2

Stage 1

Having outlined all the poppies and other plant forms lightly in pencil, I work into the poppy heads with a basic wash of orange, using a no. 2 brush.

Stage 2

I now fill in the background using a no. 1 brush and burnt umber. I select a pale yellow wash for the daisy heads and fill in the daisy petals with opaque white. The colour of the daisies contrasts well with the poppies. For the leaves, I choose a light mixture of turquoise and Hooker's green. The wheat stalks then receive a very pale wash of yellow ochre.

Stage 3

Colour mixing is important here. I try to create the soft appearance of poppies by gradually darkening the tones of orange – making sure there are no hard edges – and highlighting some of the petals in white in between the orange washes. With my finest brush I detail the petal veins, and then work into the centre of the flowers with touches of purple and black, trying not to darken the centres too much. With the tip of my brush, I emphasize some of the stamens. Then, gradually building up the washes, I work into the poppy leaves, wheat, and flower stalks, and deepen the background area.

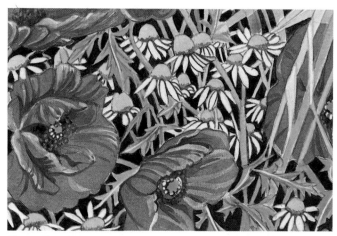

Stage 3

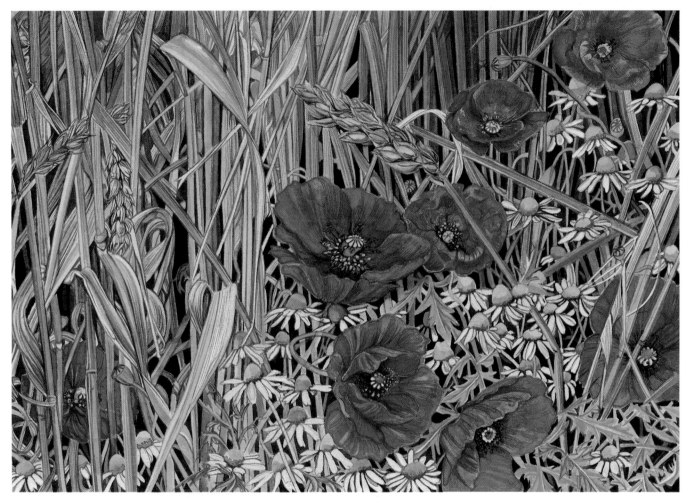

Stage 4

Stage 4 – the finished painting

I continue working into the plant forms with the tip of a no. 0 brush. Then I paint very thin lines on the wheat to create a realistic texture. I also highlight some of the daisy petals with more opaque white.

Past and present

Size: 6¼ × 8¾ inches (160 × 222mm)
Paper: Ingres Fabriano 90lb. (160gsm)
Brushes: sable nos. 1 and 3

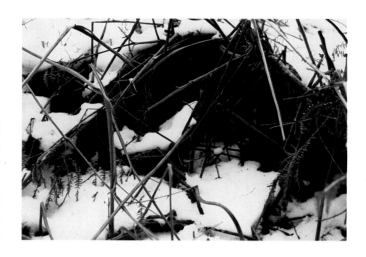

On a very cold day in January I discovered these withered ferns (right) in my local woods. I thought they made an interesting subject in themselves and also provided a strong contrast to the mass of snow around them.

Although I did not make any sketches immediately, I realized I had an ideal winter subject, so I took many photographs, using varying shutter speeds and settings. I purposely avoided using filters as I wanted the blues and grays to complement the autumnal tones of the ferns.

It is rare to find a subject already complete enough in itself to make an interesting painting (pages 23–4). This is the nearest I have come to using a single shot – I only had to redesign the elements very slightly.

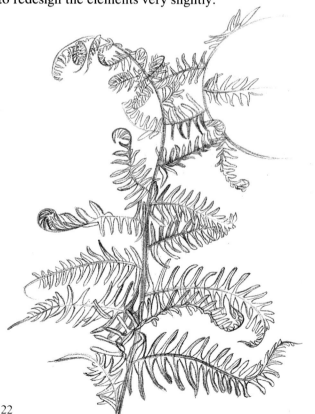

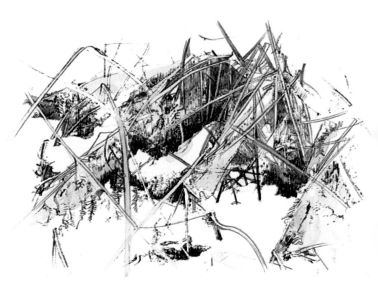

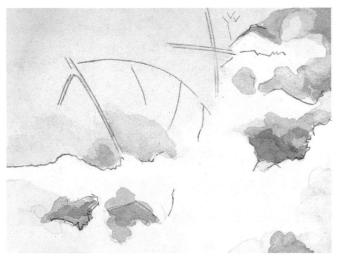

Stage 1

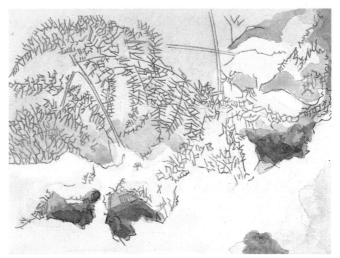

Stage 2

Stage 1

I block in the main areas of colour, covering the entire paper. Then, working on a wet surface, I lay in light to dark washes, using a no. 3 brush and mixtures of white and Prussian blue.

Because it will be difficult later to make any alterations in the area covered by the snow, I complete all of the ground before proceeding to the ferns. I then sketch in the main fern stalks with a 2H pencil.

Stage 2

Using my 2H pencil with very light pressure, I sketch in the intricate pattern of the ferns on top of the snow. Then I look at the drawing carefully and make any necessary adjustments before applying any paint to the ferns. I do not move on to the next stage until I am satisfied.

Stage 3

Working from light to dark, with thicker paint and a no. 1 brush, I now begin to paint the delicate ferns with mixtures of raw sienna, Venetian red, and orange.

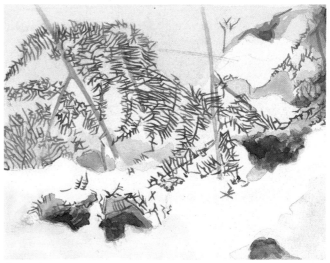

Stage 3

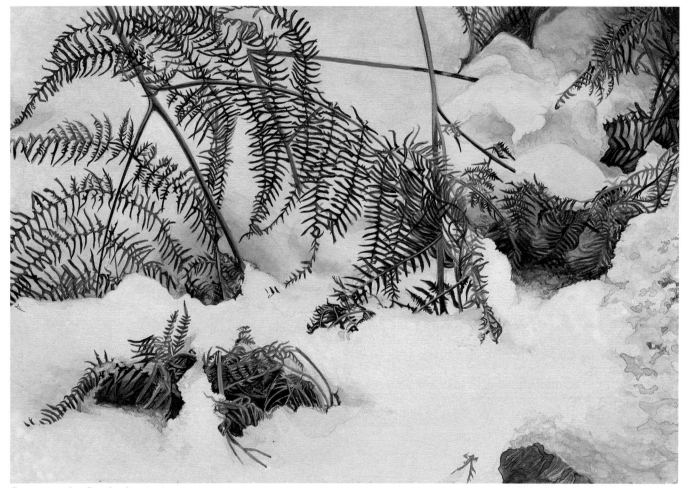

Stage 4 – the finished painting

Stage 4 – the finished painting

With a fine brush I strengthen the colour and continue working into the ferns until I have achieved the detail I want. For the most intricate parts I use a no. 1 brush, one which is almost worn out, for a brush containing only two or three hairs enables me to achieve the finest of lines. Note the delicate variations of colour and textural effects I have added to the snow.

Springtime miniature landscape

Size: 8½ × 8½ inches (220 × 220mm)
Paper: Ingres Fabriano 90lb. (160gsm)
Brushes: sable nos. 0, 1, 2, 5

This painting (pages 26–31) is based on sketches done up in the hills and on photographs taken during a showery afternoon in May. For me, the weathered stone wall – with its rich colours, emphasized by the rain, and interesting shapes and textures – sets up a challenge. I am interested in using the wall, which has a flourishing growth of moss and lichen, as a focal point in the picture.

To extend the area of interest, I include additional stones, plants, and flowers, which create the impression of a landscape in miniature.

Compare this scene with my painting *Curious* (pages 10–11). In a similar way, the scene breaks down into three principal sections: the sky, the wall, and the foreground.

I keep the sky cool and simple, in contrast to the detailed wall and entangled undergrowth. The stone wall, with its angular outlines and sharp shadows, gives me an opportunity to experiment with a variety of techniques. The foreground then provides an interesting mass of colour. If you look closely, you will notice the bright yellow of the dandelion and the daisy just beginning to open. At this time of year many other wild flowers are also beginning to appear. The nettles and grass give me the chance to paint varying patterns of green.

Pencil study of stone wall and wire

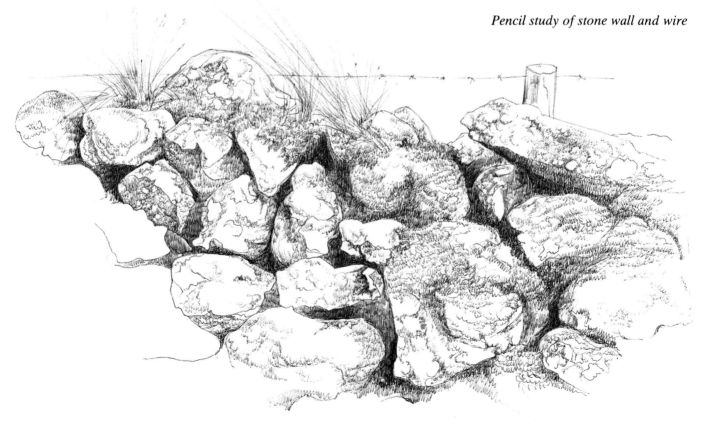

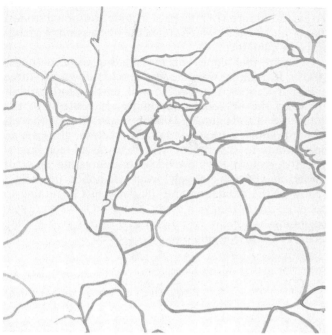

Stage 1

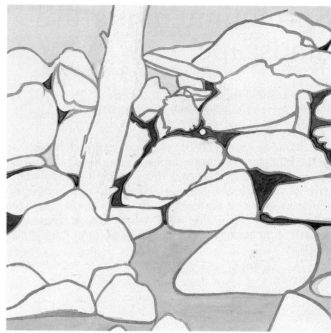

Stage 2

Stage 1

I make a linear pencil drawing of the stone shapes and wooden post, and then paint over the lines with a neutral colour, suitable to the subject-matter. I choose a blue-gray mixture and a no. 2 brush.

Stage 2

I put enough colour on my palette for the sky and ground areas. For the sky, I choose a pale blue mixture, which includes light red and violet. To cover the ground area I use a soft, fresh spring green. Working from top to bottom, I then fill in certain areas. In doing this I slightly raise my drawing board to allow the paint to run downward – a useful technique for flat areas. If a second coat of paint is necessary, I allow the paint to dry completely before proceeding. Finally, I fill in the deepest shadows between the stones, using a gray mixture.

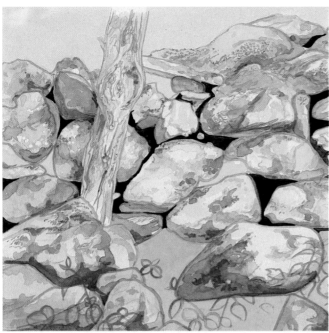

Stage 3

Stage 3

Keeping the paint thin, I try to capture the shape and colour of the post and stones. When the paint is dry, I add mixtures of sepia, yellow ochre, Hooker's green, and lemon yellow, and use a drybrush technique to suggest the moss and lichen. At this stage I begin to differentiate the textures of wood, stone, and natural growth. Using drybrush again for the wooden post and stones helps to suggest the roughness of the surface. I also indicate some of the larger plants in the foreground, such as brambles and nettles.

I leave some areas of paper for highlights, as on the stones. But, because I am working on a cream-coloured paper, I add opaque white for true highlights.

Stage 4 details

Details for Stage 4 (above)
and Stage 5 (page 30)

These two details show more clearly how I introduced those deeper tones both into the stones and into the shadow areas. The same two details from Stage 5 – see page 30 – reveal further how I then continue to work into the surfaces and plants until I give the picture the rich complication of the natural scene.

Stage 4 (page 29)
Here I introduce deeper tones of colour into the stones and shadow areas, particularly between the stones. For the darkest shadows, I use a very dark brown, as this results in a much deeper shadow than black.

Now it is time to work into the varying textures of the wooden post, stones and moss. Until I am satisfied with these I do not attempt the undergrowth.

Finally, after strengthening the colour throughout where necessary, I begin to consider the undergrowth, taking the largest plants first. I outline these in a medium shade of green and fill in various leaf shapes in a variety of greens and lemon yellow. With thicker paint, I fill in the grass, ferns, and other leaf shapes. The painting could be considered finished at any time now, but I am not yet satisfied.

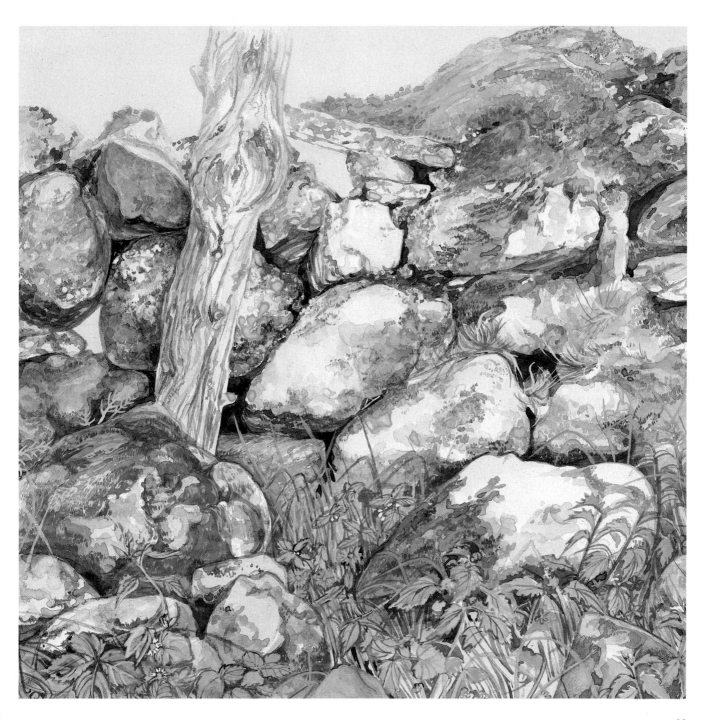

Stage 5 – details

Stage 5 – the finished painting (page 31)

As with my other paintings, this final stage may appear complicated and difficult to achieve. But, once again, it is a question of taking one step at a time and paying special attention to the delicate plant structures on the wall and to the stone textures. See the two details above.

I continue to work into those surfaces and plants, using a fine but well-worn brush for the detail. I take special care with the lichen on the wall, working light to dark with thick paint. At the last moment I add the barbed wire to give the whole painting an extra horizontal interest.

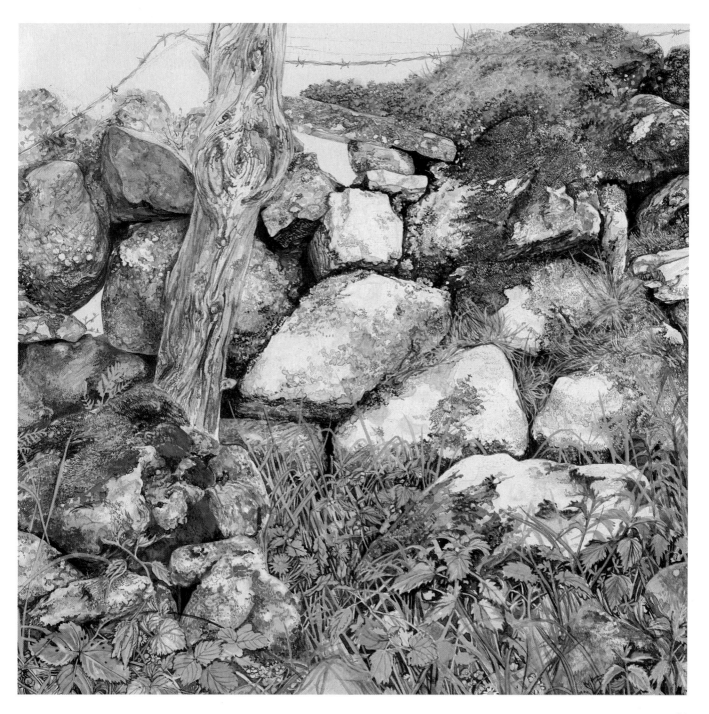

First published 1987
Search Press Limited,
Wellwood, North Farm Road,
Tunbridge Wells, Kent TN2 3DR

Text, drawings and paintings by Sylvia Fratini

Reprinted 1990, 1993

The material in this book has previously been
published in *Painting the Secret World of Nature* by
Sylvia Frattini, James Lester, Benjamin Perkins and Rosanne Sanders
published by Search Press Limited in Great Britain and
by Watson-Guptill Publications in the USA.

ISBN 085532 596 8

Distributors to the art trade:

UK
Winsor & Newton,
Whitefriars Avenue, Wealdstone,
Harrow, Middlesex HA3 5RH

USA
ColArt Americas Inc.,
11 Constitution Avenue, P. O. Box 1396, Piscataway,
NJ 08855-1396

Arthur Schwartz & Co.,
234 Meads Mountain Road, Woodstock, NY 12498

Canada
Anthes Universal Limited,
341 Heart Lake Road South, Brampton, Ontario L6W 3K8

Australia
Max A. Harrell
P. O. Box 92, Burnley, Victoria 3121

Jasco Pty, Limited
937-941 Victoria Road, West Ryde, N.S.W. 2114

New Zealand
Caldwell Wholesale Limited,
Wellington and Auckland

South Africa
Ashley & Radmore (Pty) Limited,
P. O. Box 2794, Johannesburg 2000

Trade Winds Press (Pty) Limited,
P. O. Box 20194, Durban North 4016

Typeset by Phoenix Photosetting, Chatham, Kent
Printed in Spain by A. G. ELKAR, S. Coop. - 48012 BILBAO